Invisible Jumpers

Invisible Jumpers

Photography by Joseph Ford

Knitting by Nina Dodd

HOXTON MINI PRESS

The Slow Picture Movement

Laura Noble

How reassuring it is to immerse ourselves completely into our surroundings and feel part of the very fabric of a place we inhabit.

Finding the perfect environmental 'fit' can conjure that elusive sense of belonging and permission to be at ease and be our true selves. For some, that place is in their home. For others it may be at work or at play. It may even be the case that absence from the familiar, exploring new territory, is where one finds the most connection and belonging from their environment. Yet the definition of home and how we present ourselves is changing. Social media has enabled us to carefully crop, edit and curate our identity, to literally and figuratively filter to cover the cracks. We become simultaneously more sensitive to, yet less aware of our actual surroundings. We are slowly losing our ability to release our control over our image. Where did all the fun go?

What happens when we place our appearance in the hands of another?

Sometimes if we are really lucky, magic!

When Joseph Ford embarked upon *Invisible Jumpers*, he wanted to create a joyful place; one that showed all the joins and didn't pretend to be perfect. He didn't want to completely erase anyone in favour of the 'scene', rather heighten the aesthetic of every scenario with each subject. All the images involve a great deal of labour. To obscure these efforts would be to deny it to viewer, model and creators. The project is a labour of love and the homespun nature of the interventions does not feel fabricated.

Ultimately this is a fun yarn about how things look. Ford did not seek to depict the minutiae of each sitter's personal story. Rather, he focused on the aesthetic possibilities each carefully sought sitter brought to complement the locations he had chosen to photograph. With a pre-designed concept of how the finished article would appear he set about finding models and planning scenes.

Ford worked with a talented knitter called Nina Dodd, who knits the world in her own unique way and aims to 'push wool to its limits'. Her enthusiasm for the quirky resulted in a literally made-to-measure collaboration on this camouflage knitting mission. On average, each jumper consists of 40-50 hours of knitting. Some are more complex than others, as each must contour to match and seams merge as seamlessly as possible into the scene when worn. Like Georges Rousse's in-situ optical illusions, just one step to the left could unravel the artifice completely.

We believe that we look at the objects, people and places that surround us every day. However, our appreciation of our environment is reduced by the sheer cacophony of imagery bombarding us from dawn to dusk. More often than not, we are merely glancing at the world.

Our attention is further stretched by an abundance of devices, phones, tablets or computer screens. Habitually we

view the world, especially ourselves, through our devices. Even when we are standing in front of something which interests us, the itch to photograph and record it is insatiable, yet ultimately unsatisfying. We are addicted by the immediacy of the social media image yet that somehow diminishes its power to hold our gaze. The pleasure derived from looking through a book or photo album remains more satisfying than any Instagram feed can ever be.

Persistent and concentrated observation is a rare thing. We make many assumptions and take many pictures which are never studied in any detail. So how in the midst of this does a photographer focus our attention on any one image for any length of time? Joseph Ford thought he could with a combination of fun, fact and fiction.

By partially camouflaging his subjects, dressed with couture customised jumpers, in a variety of eclectic settings - many of which he had always wanted to photograph – Ford has created a series of incredibly arresting pictures.

Amongst these bespoke optical adventures, two models did have connections to their environment that proved impossible to resist. In the case of Fatboy Slim, a giant acid house smiley on his roof insisted on being photographed. In doing so, Norman Cook's playful performative alter ego is perfectly expressed (p.34).

Ford had 'always loved the cheerful anarchy' of Parisian artist Monsieur Chat's work (the Swiss-born graffiti artist who has been painting grinning yellow cats on the walls of his adopted city, Paris, for the last 20 years). Ford discovered his work on moving to France as a student, so a collaboration in a location near the painter's studio seems an almost pre-destined tribute to his oeuvre (p.52).

Ford is not necessarily concerned with personal stories, although this is not to say that there aren't stories contained within the making of the images. Identical twins Mady and Monette Malroux had been a long-admired pairing to Ford. Adorned in matching tutus, filled with mischievous abandon, their life-long interwoven existence fitted the project perfectly. They capture our imagination immediately, appearing cryptic from the onset (p.26).

These pictures invite us to unravel and separate the wool from its immediate vicinity, then knit them back together again with our eyes. The illusion is not meant to trick us completely. In order to retain the 'real' and show the analogue nature of the knitted area we can see that it truly exists in the world beyond the image. We find our vision blending both elements together whilst revelling in their differences. As a result, this visual dislocation and recoupling keeps each image fluid whilst the homemade authenticity prevents us from feeling unsettled.

So, sit back and relax. Transport yourself into these scenarios. Try to work them out, but don't try too hard, and become part of the Slow Picture Movement.

Calum, 2017

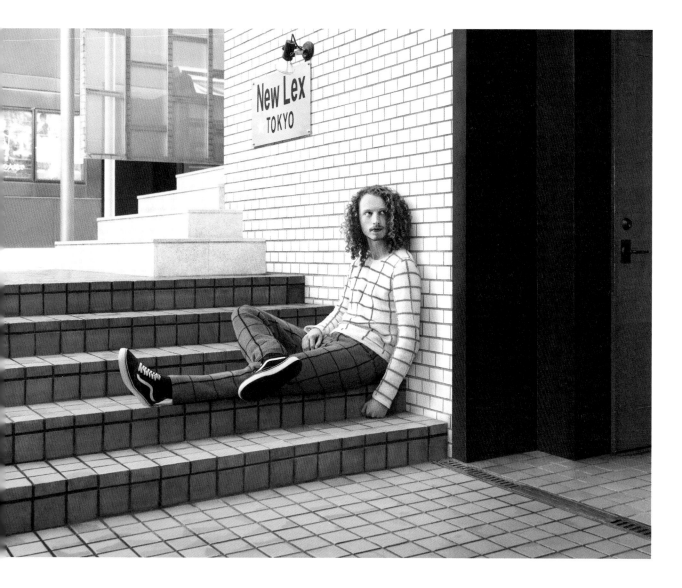

Buddy and Taboushka, 2018

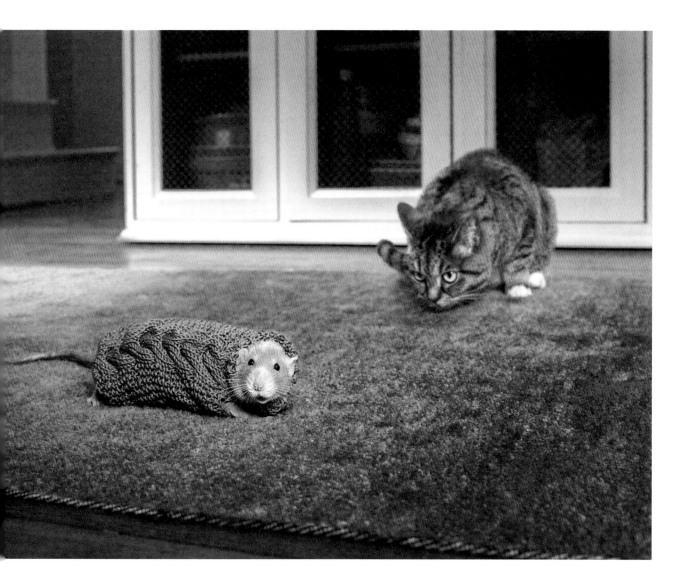

Lo, 2018

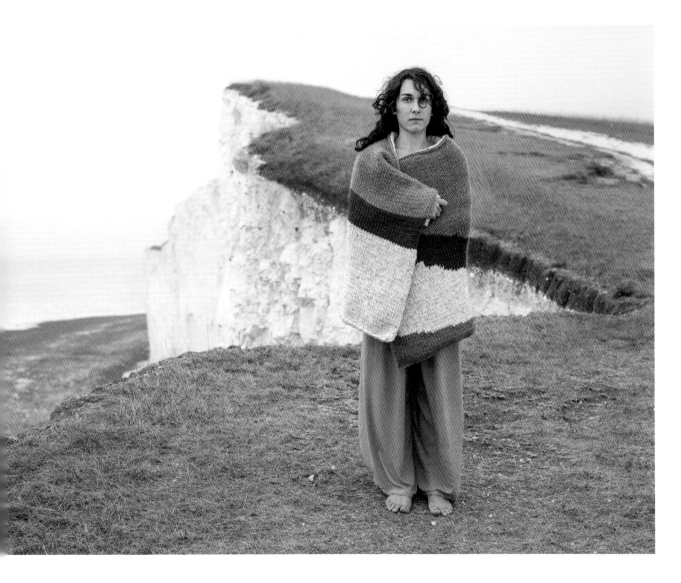

Rumi and Scarlet, 2019

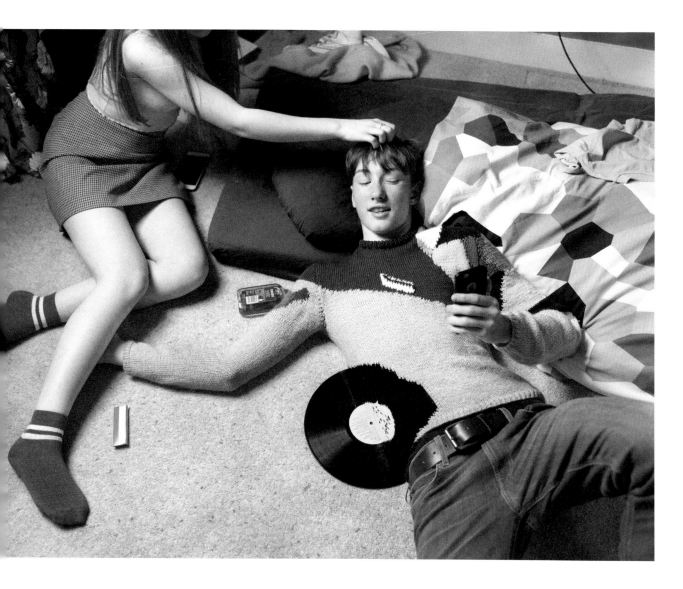

Chris, 2019

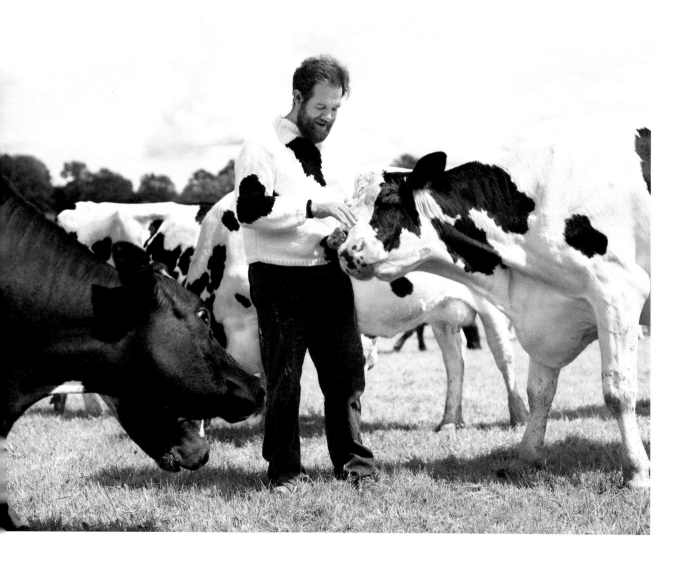

Malik, 2016

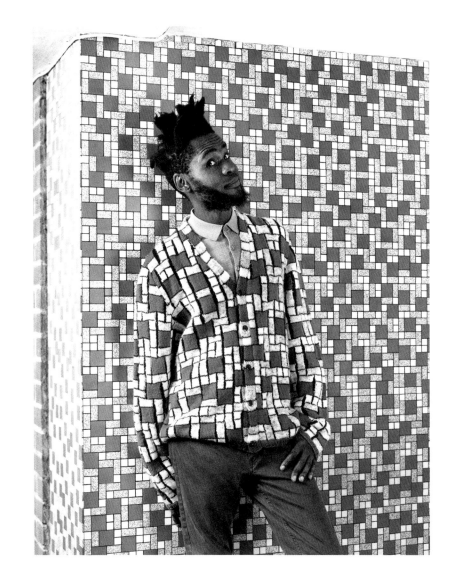

Popay, 2019

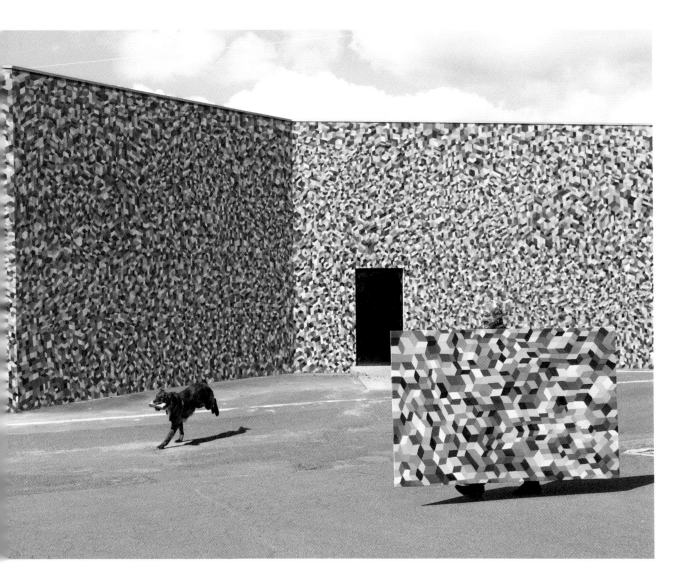

Kate, 2019

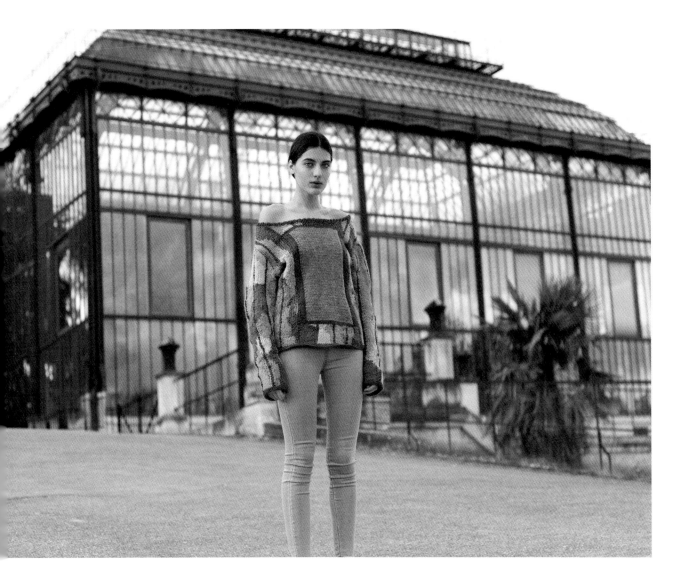

Jimmy, 2014

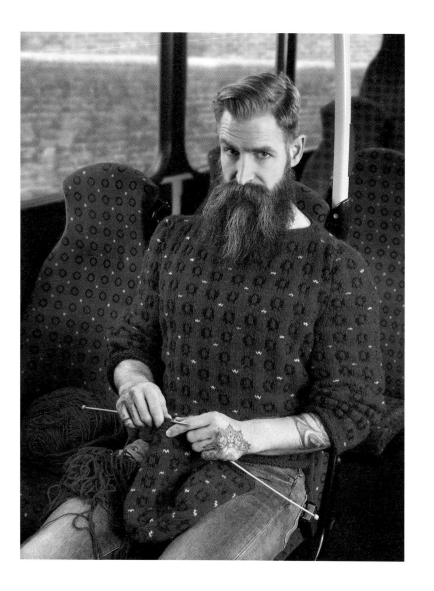

Dre and Tom, 2019

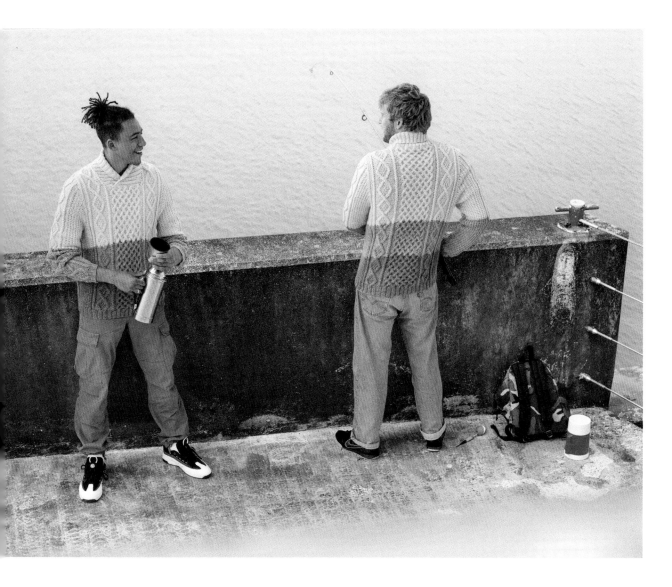

Mady and Monette, 2015

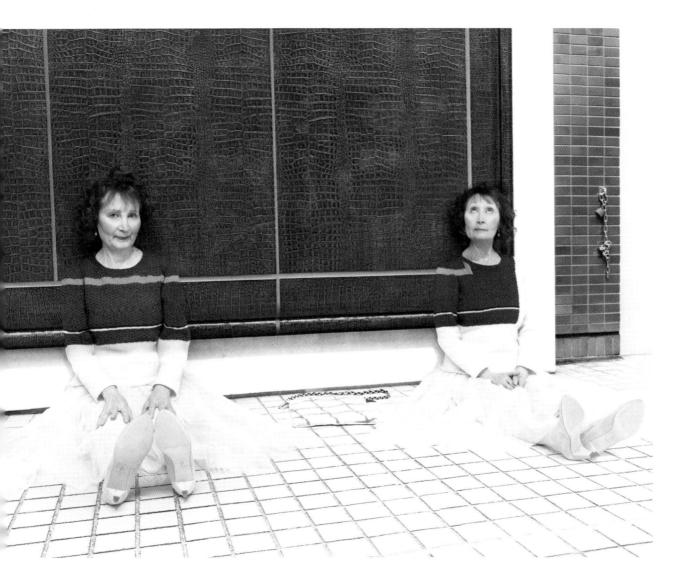

Tea time, 2018

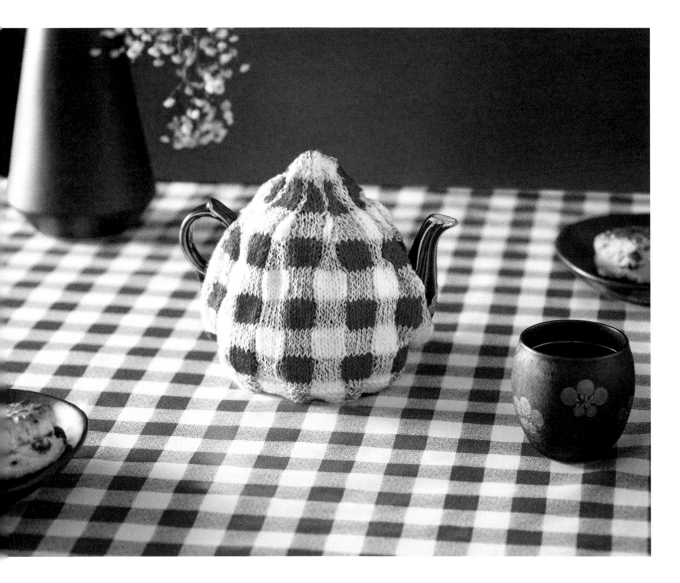

Seth, 2019

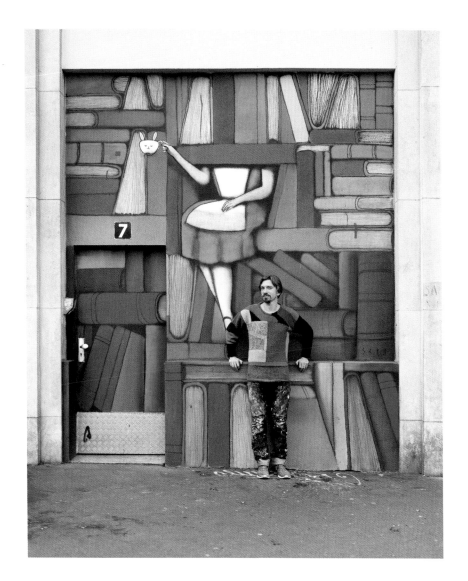

Black Phoenix, 2019

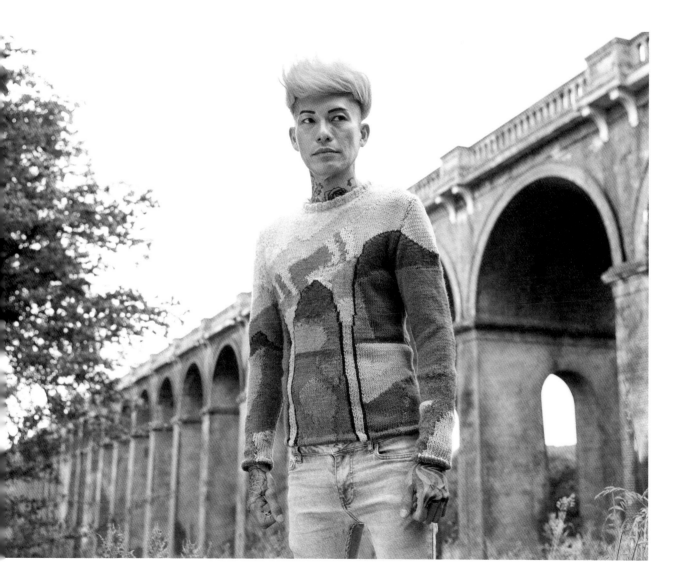

Fatboy Slim, 2018

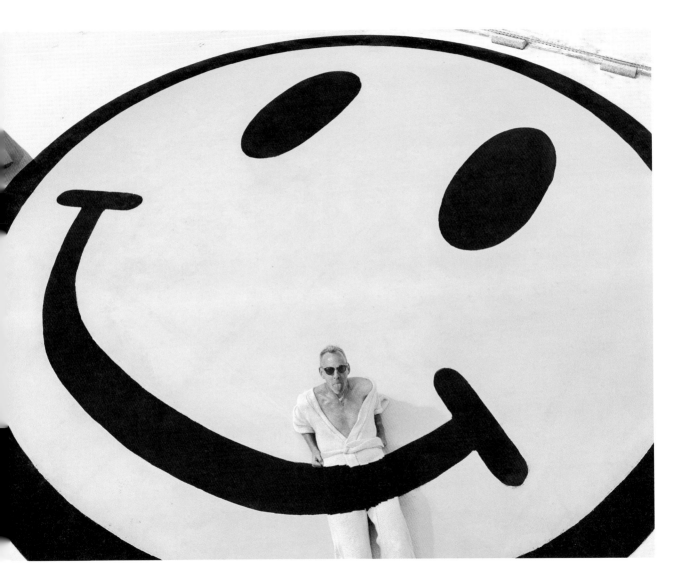

Fruit fraud, 2019

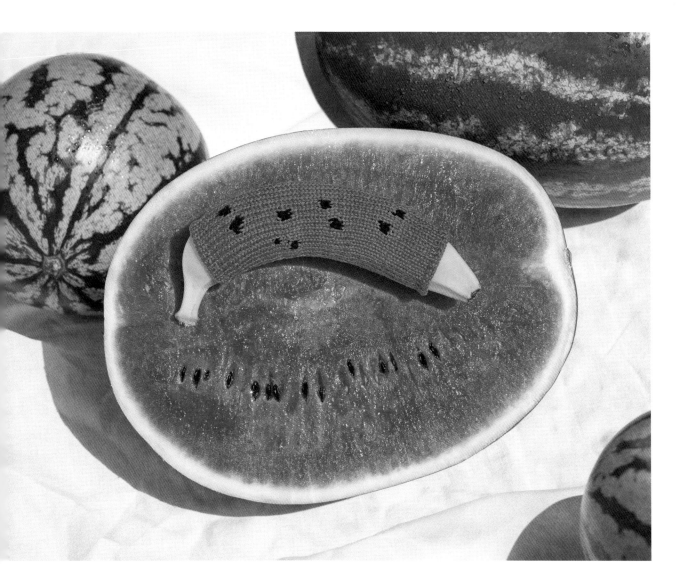

Self-portrait, 2019

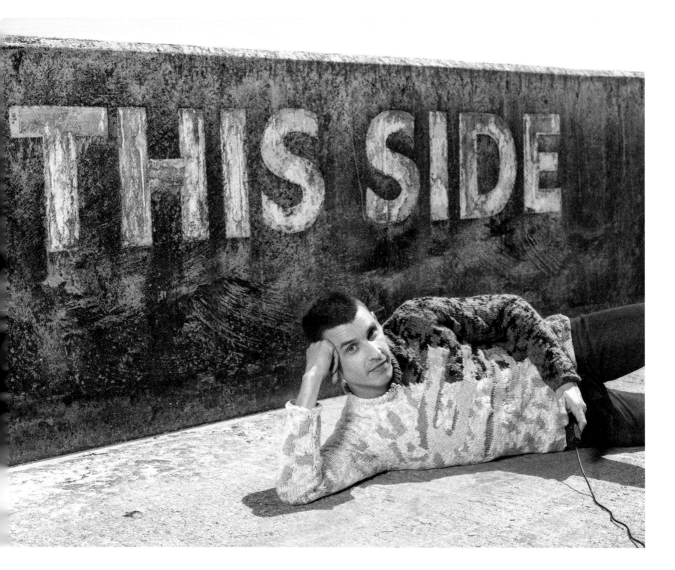

Marianne, 2019

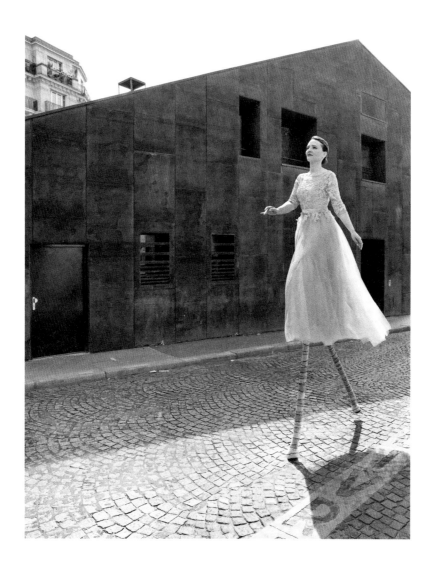

Fimber Bravo, 2018

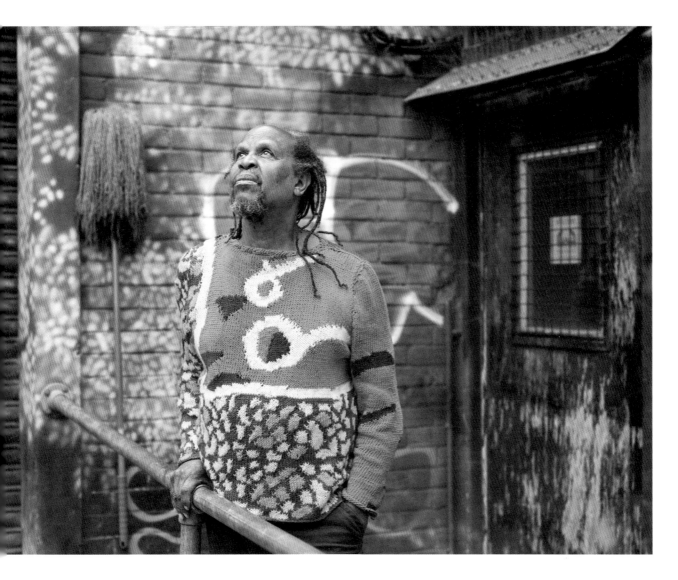

Eva and Nico, 2018

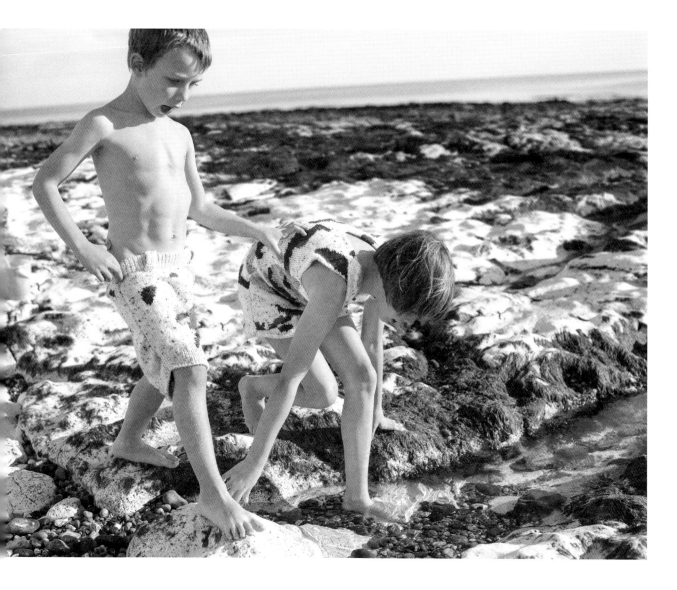

Yalie, 2015

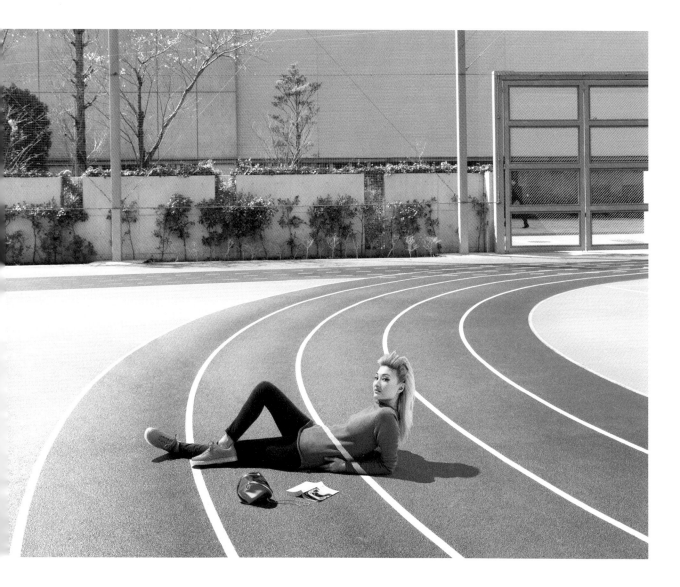

Nina, 2018

Isobel, 2019

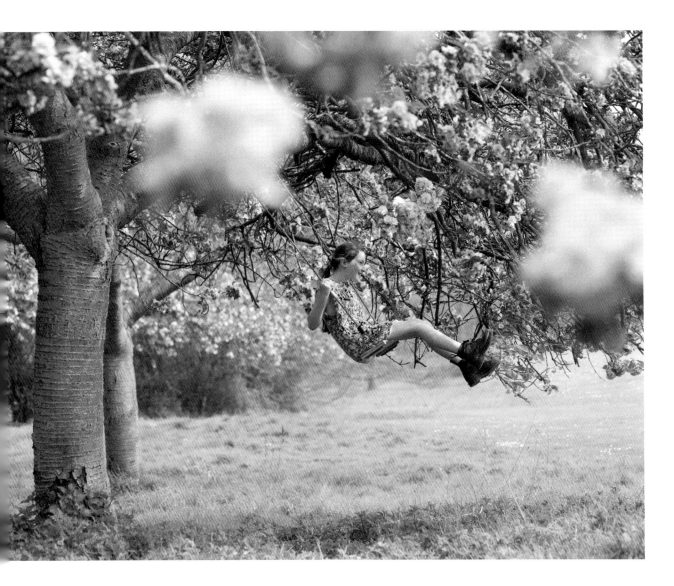

Monsieur Chat, 2017

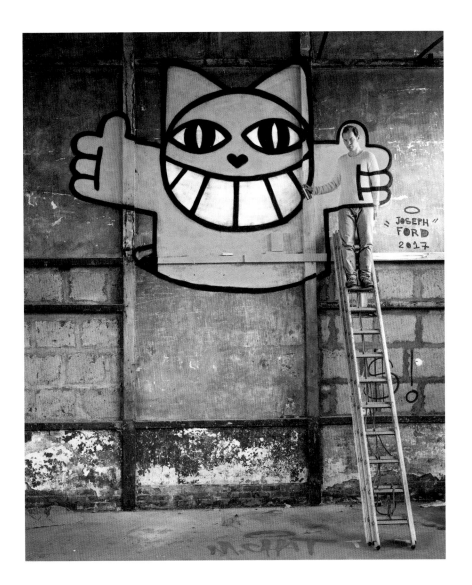

Venus, 2015

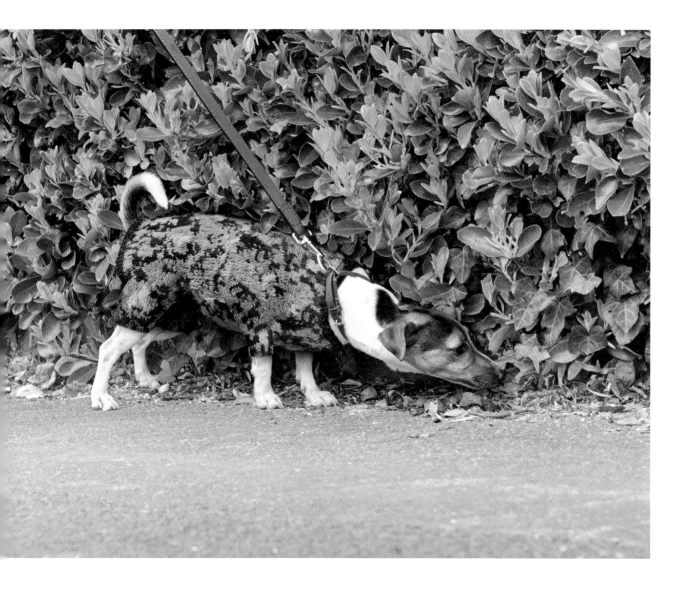

Behind the knitting

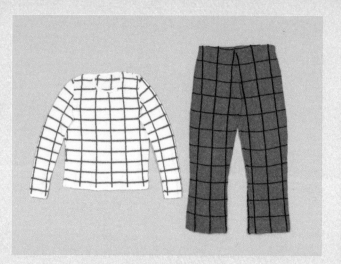

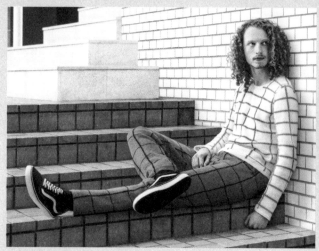

Calum, 2017 (p.6)
Jumper: 42 hours knitting
Trousers: 55 hours knitting

Calum's amazing hair made him the perfect model. While I want some parts of the people I photograph to blend into the background, I love having a detail that makes them stand out. This outfit holds the honour of the most time-consuming knit, with a total of 97 hours on the needles.

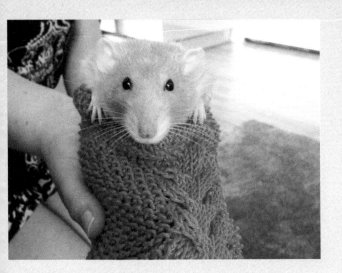

Buddy and Taboushka, 2018 (p.8)
8 hours knitting

I loved the ridiculous notion of a rat in disguise, sneaking past a cat. Nina worked out an intricate cable-knit pattern and we spent ages picking the right yarn to match the rug. Buddy moved fast but gave me a quick glance before scampering off. To reassure anyone who might be worried about how this scene played out, we photographed each animal separately. And gave Buddy a piece of cheese afterwards, of course.

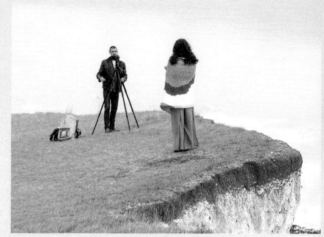

Lo, 2018 (p.10)
34 hours knitting

I scouted Lo on the street in Brighton and she agreed to model
the blanket on a clifftop near Beachy Head a few days later.
As we shot, my assistant struggled to hold a huge reflector
against the wind that threatened to carry it (and him) away
into the English Channel.

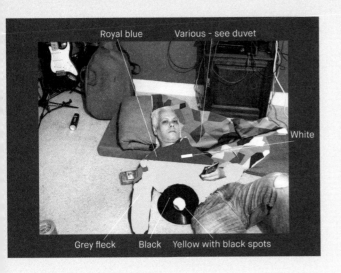

Royal blue Various - see duvet

White

Grey fleck Black Yellow with black spots

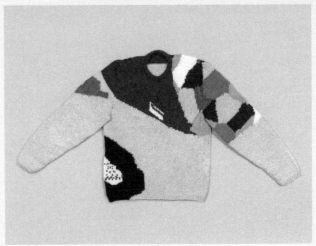

Rumi and Scarlet, 2019 (p.12)
61 hours knitting

I've photographed a range of ages for this project, and the idea of recreating a messy teenager's bedroom appealed to me. Nina's partner posed in a jumper covered in gaffer tape. I added accessories around him, drawing matching lines on the taped jumper. I then photographed the annotated top and marked it up with colour indications. This gave Nina a model to work from, allowing precise placement of lines to match the accessories.

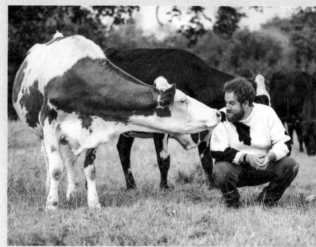

Chris, 2019 (p.14)
27 hours knitting

Chris is my best friend from school. He works with a charity called Bore Place which has an organic dairy herd. The shoot began smoothly enough, but then my assistant pointed out a bull advancing towards us. We couldn't photograph the cows anywhere else so had to spend the rest of the shoot keeping an eye out for the bull, who chased us away every time we spent too long in one place.

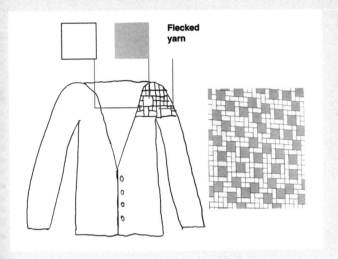

Flecked yarn

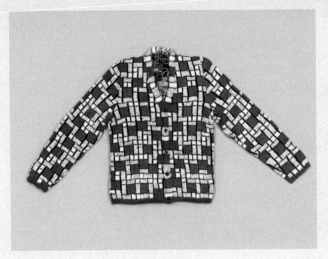

Malik, 2016 (p.16)
63 hours knitting

This was shot in Brighton with a South African musician, Malik.
Nina spent several months creating this cardigan which was
massively complicated by the variety of shades and colours
on the wall and by the small size of the squares.

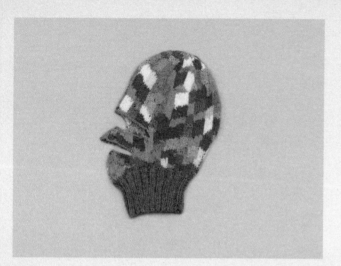

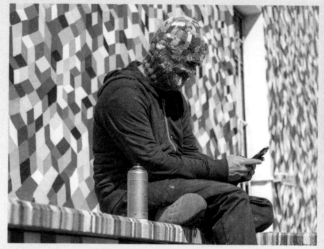

Popay, 2019 (p.18)
20 hours knitting

Seth (p.30) introduced me to Popay, a fellow street artist. Popay was working with 20 different colours on this wall, and I tentatively sent Nina a picture. She refused at first. 'Maybe we could do something smaller?' I suggested. 'A balaclava?' Nina always rises to a challenge and produced a rather terrifying balaclava, using a skull borrowed from a medic friend to help her shape it.

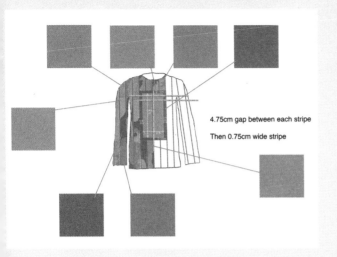

4.75cm gap between each stripe

Then 0.75cm wide stripe

Kate, 2019 (p.20)
48 hours knitting

Kate was a 16-year-old model from a small town in Belarus. She was trying her luck modelling in Paris during her school holidays. This 19th century greenhouse is in Paris' botanical gardens, the Jardin des Plantes. The hue of the glass varies according to the light: viewed from one side it can be green, from another pink or purple. It was a cold day and I was glad, for Kate's sake, that Nina had used thick, warm wool.

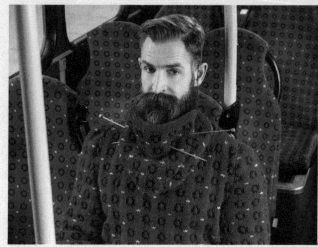

Jimmy, 2014 (p.22)
50 hours knitting

Jimmy was in the local barber's when Nina spotted him through the window. Little did he know he was about to be press-ganged into posing for an eccentric picture. He agreed to model and Brighton & Hove Buses kindly lent us a bus for the shoot. Everyone loved this first picture and I started hunting for more ideas.

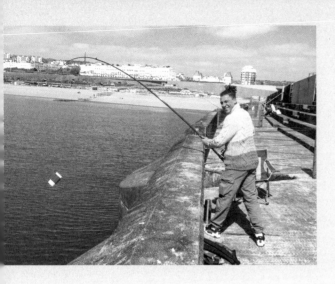

Dre and Tom, 2019 (p.24)
48 hours knitting

Often when looking for models I wander the streets for hours or days, searching for inspiration. I'd wanted to step away from the stereotypes of people who fish so I went to a skatepark. Tom and Dre were surprised to be asked to model but agreed. I'd scouted the location on a grey day, and the jumper colours only matched the sea wall when the sky was overcast, so we had to wait hours for clouds to come over.

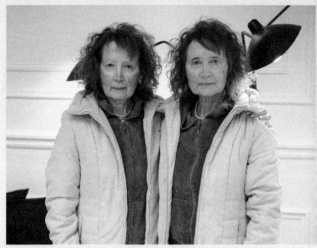

Mady and Monette, 2015 (p.26)
85 hours knitting

Parisian twins Mady and Monette Malroux have lived together all their lives; they dress identically and do everything together. They feel sorry for people who are 'singular', as they describe people who aren't twins. They acted as each other's mirrors while dressing. Monette tried on her jumper and Mady admired the effect. One of them commented, 'We love them'. Without needing to ask her sister's opinion she knew they both felt the same way.

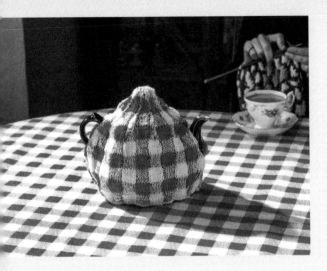

Tea time, 2018 (p.28)
7 hours knitting

It couldn't really be a book about a British knitting project without getting tea involved. However, hiding under that very English tea cosy is a Russian teapot. I'm sure there's a metaphor in there somewhere.

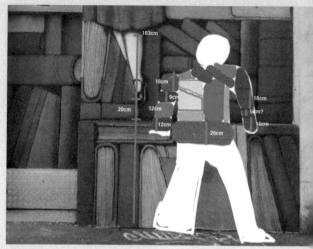

Seth, 2019 (p.30)
48 hours knitting

Street artist Julien Malland, aka 'Seth', had painted a series
of murals in Paris, all based on children's books. I chose this
playful depiction of *Alice in Wonderland* as a background.
There is always a risk with street art that someone might
graffiti over it, which made for a nerve-wracking wait while
Nina knitted the jumper, but we were lucky.

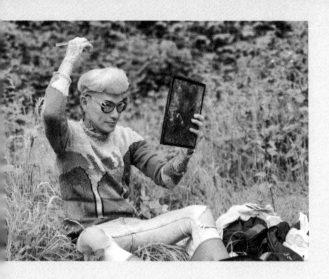

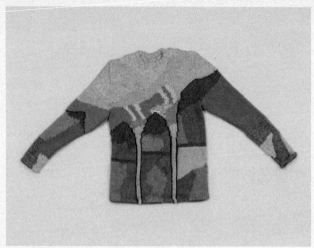

Black Phoenix, 2019 (p.32)
49 hours knitting

I shot this model, known as Black Phoenix, at Balcombe
Viaduct, built during the Victorian railway boom. I'd scouted
the location in the winter when the surrounding ground was
grassy, but by early summer the area I had picked was waist-
deep in nettles. After a determined onslaught using my camera
case as a scythe, we managed to clear enough space to shoot.

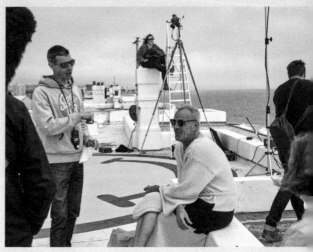

Fatboy Slim, 2018 (p.34)
63 hours knitting

Norman Cook, aka DJ Fatboy Slim, has a thing for smileys, a theme that extends to the roof of his house. I balanced on the highest step ladder I could source, taking advantage of the biggest tripod I own, while Norman laid back and squinted into the sun in his knitted robe, blending in to the eight-metre-wide smiley face. His comment on the project? 'I love this kind of attention to the absurd. Right up my street.'

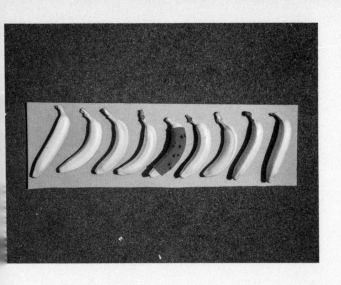

Fruit fraud, 2019 (p.36)
4 hours knitting

After cutting open a few watermelons and setting up the
lights, it turned out the melons I'd bought were seedless. Oops.
The second time round, I questioned the shopkeeper carefully
(cue strange looks) and he reassured me that these ones had
pips. I bought about 15 kilos, which gets you two large water-
melons and one small one. Then it was time for the banana
casting. Not too straight, not too bendy...

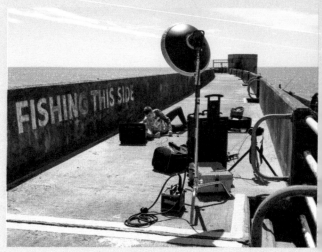

Self-portrait, 2019 (p.38)
50 hours knitting

Shooting this self-portrait was not a relaxing process. However, several people suggested that I should be in one of the pictures and I did like the idea of wearing one of Nina's amazing creations. Foolishly, I picked one of the first really hot days of summer to wear a thick woollen sweater. My assistant enjoyed my discomfort.

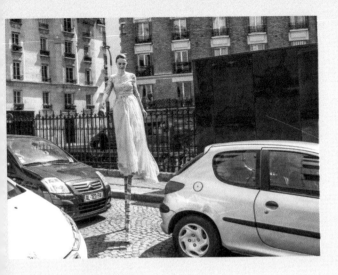

Marianne, 2019 (p.40)
32 hours knitting

I liked the idea of an elegant woman walking along this Parisian street, contrasting with the rusty metal façade rather than matching it. I had to think of a way to use knitwear to help her stand out. Ah-ha, stilt covers blending into the cobbles, of course! My assistants managed to persuade drivers to leave a space in the traffic every now and then so we could shoot while Marianne strode across the slippery cobbles.

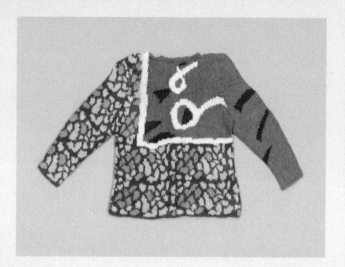

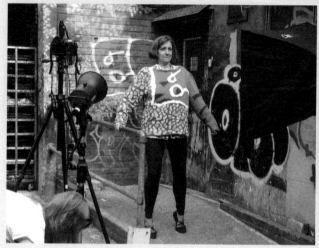

Fimber Bravo, 2018 (p.42)
49 hours knitting

This loading bay location in Brighton called out to me. I loved
the rich palette of greens and blues, the dilapidated door
and the ragged grey mop against the wall. Irresistible. It
seemed the perfect place to photograph Fimber Bravo, the
renowned steel pan player. I'd come across his captivating
music a few years ago and wanted to work with him for a
while. Nina (pictured) helped to model the jumper first.

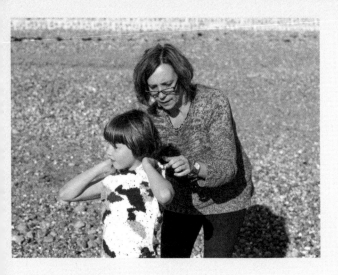

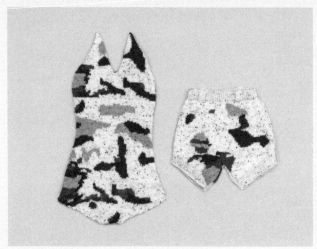

Eva and Nico, 2018 (p.44)
Shorts: 19 hours knitting
Swimming costume: 30 hours knitting

This picture is special to me because it features my children. Like most kids, they love exploring rock pools. This was shot near Brighton on an unseasonably warm day at the end of October. Nina used 1950s swimming costume patterns for the authentic itchy woollen feel. My kids loved playing around in them for a couple of hours but commented that they were pretty uncomfortable!

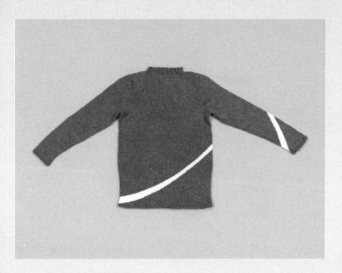

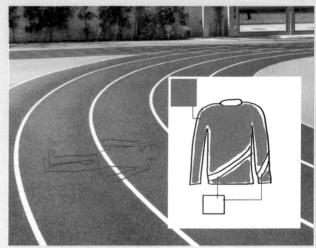

Yalie, 2015 (p.46)
43 hours knitting

This was the first picture that involved knitting and photo-graphing clearly defined lines. I marked out on a t-shirt the line for Nina to knit, viewed from the correct angle. This made it possible to have a slightly curved line running over a three-dimensional torso. However, this created an additional challenge when photographing: the model had to hold exactly the right position and be shot from the perfect angle to make everything match up.

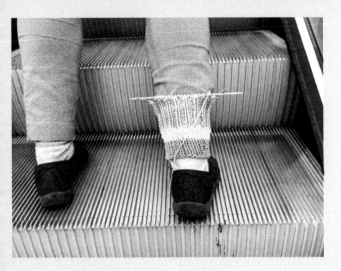

Nina, 2018 (p.48)
10 hours knitting

For this picture, Nina modelled her own knitwear. Some of the photographs in this book have taken hours to get lined up properly but this was remarkably simple, which was fortunate because, after a few minutes, we saw security guards converging on us. We made a hasty retreat and got away unchallenged.

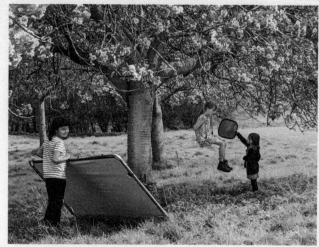

Isobel, 2019 (p.50)
68 hours knitting

The more abstract backgrounds, like this one, are the most challenging to knit. Nina almost refused this concept but we settled on a child's sleeveless dress to minimise the amount of needle time. Even so, it almost finished Nina off; at one point she had 24 balls of yarn on the go. Then there was the challenge of finding the trees in bloom.... We got there, eventually.

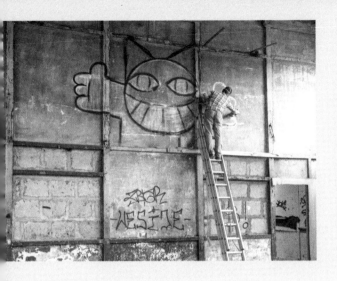

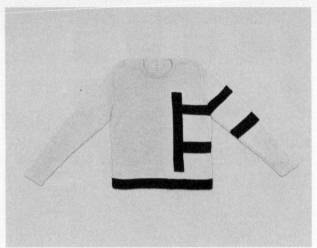

Monsieur Chat, 2017 (p.52)
48 hours knitting

I was lucky enough to spend a couple of days with renowned
street artist Thoma Vuille, aka Monsieur Chat. We scouted for
locations near his studio on the outskirts of Paris, eventually
climbing over the wall of an abandoned factory. It was sched-
uled for demolition so the pressure was on for Nina to knit
fast. I returned a month later with the completed jumper and
Thoma painted his trademark grinning cat to match. I hope
it made the demolition crew smile.

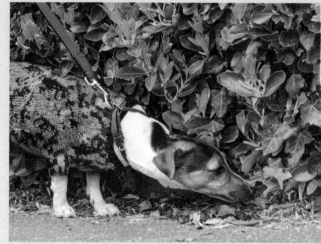

Venus, 2015 (p.54)
37 hours knitting

Nina cursed me while working on this jumper. As a non-knitter, I hadn't considered that the random nature of a leaf pattern would be difficult to knit. While shooting, we spent most of the time trying to disentangle Venus while she was busy exploring the hedge. The dog coat itself has since disappeared, unfortunately. Nina claims it was lost when she moved house but I suspect she might have burnt it.

Loose threads

Why I take pictures of jumpers

Joseph Ford

I love creating optical illusions and capturing them on camera. Before beginning this project I wanted to explore optical illusions with a human element. Enter Nina Dodd. We had met a year or two before when I was working on an unrelated project that required some inventive knitting. She showed me a jumper she'd knitted based on bus seats. This seemed too good an opportunity to miss, so I suggested finding an eye-catching model and photographing him in situ on a bus. After this, I asked Nina if she could knit another camouflaged jumper, which led to another, and another, and another.

Knitting is the ultimate analogue process, complete with imperfections and replete with detail. At a time when it is often assumed that anything out of the ordinary in photography is solely the result of CGI or Photoshop, it is satisfying to work with a deliberately slow, hand-crafted medium. The results aren't perfect and there are bits that don't match up.

Each of these pictures has taken me several days or weeks to research and plan, and Nina has spent weeks, sometimes months, knitting each garment. The locations have to be striking but simple enough to be knitted. They also have to be places that aren't going to change too fast.

Once I've found the location, I photograph someone standing where I would like the model to be in the final picture. I draw over this scouting photograph and mark up the picture with different colours and patterns so that Nina can plan how to knit. Often there are 10 or 12 different shades of yarn in a single picture, and we've chosen shiny cottons or matte wools according to the background textures.

When the knit is complete, it's time to find the model. I've wanted to photograph people who bring something extra to the shot and spent several days in search for the perfect subject for some pictures, while other models have been chance encounters.

Once we get to the shoot the stakes are high. I'm always nervous that something will have happened to the location, that the colours won't match or the scale will be wrong. There's been a definite learning curve – I now know that abstract patterns are simpler than straight lines, for example. It's immensely satisfying to see the model blending into the background on each shoot and to realise that all the preparation has been worth it.

Why I knit jumpers that blend into bus seats

Nina Dodd

I've always loved travelling on buses. One day, while I was on the number 5B in Brighton I was struck with the idea of knitting a jumper that blended into a bus seat. I literally got off at the next bus stop to buy the wool and get started. I had knitted a number of detailed, unusual pieces before but nothing that had to be quite so accurate. I was up for the challenge.

We were both really pleased with the first (front cover) image, so when Joseph suggested more knitted camouflage I couldn't say no. We have had long conversations about what is and isn't possible, but I generally work on the principle that if it's conceivable, it must be knittable! Joseph has pushed this to the limits, though – I can't think of many people who have been asked to disguise a pair of stilts into a cobbled Parisian street.

After agreeing on an image there's a period where all sorts of design ideas swirl around my head. This is usually followed by getting a pattern onto knitting graph-paper, then a number of trials with colours, tension and sizing, which involves knitting, undoing, knitting again and much cursing. Although several of the pieces involve similar techniques, there has been a huge variety in terms of types of garments, wool sizes and patterns. I never knew I'd have to decide what sort of cable knit would suit a well-proportioned rat, for example.

Without a doubt, two of the most challenging knits were the dog jumper (p.54) and cherry blossom dress (p.50). Both involved up to 24 balls of wool on a single row of knitting, working a maximum of five stitches before changing colour. I'm really pleased with how the final pictures look, but I was delighted to put those in the 'done' pile.

Handing over the jumpers to Joseph is a nerve-wracking moment. I've been on a few photoshoots but often the next thing I see after completing each piece is the end photograph. Seeing a garment that has grown slowly over weeks in my home and then the finished image is a magical thing. I'm delighted to be able to see them all together in this book.

Joseph Ford

Joseph was born in London. When he was eight his mother taught him to knit and his father gave him a camera. Only one of the skills stuck but the knitting must have had an influence. His work concentrates on optical illusions and he spends most of his time thinking up over-complicated projects.

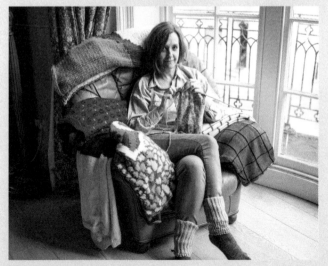

Nina Dodd

Nina Dodd lives in Brighton. From a dress made of all the flags of all the countries in the Eurovision Song Contest to an eight-metre wide pier, Nina will knit anything that floats into her head. She has a day job at Brighton & Sussex Medical School but even uses this as an excuse to knit microbes and scabies mites.

Joseph would like to thank...

Nina, for everything. Many other people have helped me complete this project. Thanks to all of you, especially everyone who has posed for me, and apologies to anyone I have missed out: Matt & Pete at Additive, Stanislas Belhomme, Bore Place, Carol at Brighton & Hove Buses, Lilli Burridge-Payne, Ela Calin, Charis Cassell, Julie Camus, Emma Coquet, Connor Daly, Dorothée Dauger, Peter Dennis, Amelia Ellison, Bobbie Farsides, Florence Ford, Sébastien Goepfert, Neal Grundy, James Hole, Franziska Holzer, Infinity Foods, Andras Jambor, Sue Johnson, Matthew Kahn, Max Langran, Stefania Lanza, Yann & Karine at La Plateform, Clémentine Lemaître, Rosie Mahoney, Georgia Meinert, Sophy Mirti, Barbi Mlczoch, Laura Noble, Margaux Rousse-Malpat, Nicolas Scordia, Tom Cole Simmonds, Barbara Soulié, Louise Turner, Renda van der Burg. This book is for Elizabeth, Eva and Nico.

About Hoxton Mini Press

Hoxton Mini Press is a small, award-winning publisher based in East London. We started out by making photography books just about Hackney, working with local artists and writers, but now we make books about other topics, like, er, jumpers. Basically, we are inspired by niche stories told through rich photography. As the world goes online and we live in the cloud we believe that books, and the stories within them, should be cherished and stored on neat wooden shelves and then passed down through generations. For more details, please visit: www.hoxtonminipress.com.

Invisible Jumpers

First edition

Copyright © Hoxton Mini Press 2019. All rights reserved.
All photographs © Joseph Ford
Knitting by Nina Dodd
Introduction text © Laura Noble
Design by Daniele Roa
Text editing by Faith McAllister
Production by Anna De Pascale
Repro by Touch Digital

First published in the United Kingdom in 2019 by Hoxton Mini Press.

ISBN: 978-1-910566-58-9

Printed and bound by OZGraf, Poland

To order books, collector's editions and signed prints please
go to: www.hoxtonminipress.com